PHOTO OOPS

photographic opportunities
gone awry

PHOTO OOPS

photographic opportunities gone awry

HAL BUELL

BLACK DOG
& LEVENTHAL
PUBLISHERS
NEW YORK

CIP available

ISBN: 1-5792-078-4

Manufactured in the United Kingdom

j i h g f e d c b a

Published by
Black Dog & Leventhal Publishers Inc.
151 West 19th Street
New York, NY 10011

Distributed by
Workman Publishing Company
708 Broadway
New York, NY 10003

Dedication

Animals figure prominently in politics but somehow remain above and removed from the turmoil that surrounds them. There's been Fala and Checkers…and Him and Her and Yuki…and Millie, who wrote a book of her own.

But Socks the cat, resident of The White House at the millenium, seems to possess a special aloofness that sets him apart. He survived political whirlwind and photographers offering Pounce. With arched back and a serious spit, he hissed his way past rambunctious Buddy, the new White House resident who was clearly more upsetting than either the politics or the photographers.

And so we dedicate this book to Socks, who could teach politicians a thing or two about survival, about staying the course through thick and thin, about coping with critters of all sizes and shapes and about moving effortlessly through bands of tireless photographers crying for 'just one more.'

Socks maintains his cool with an elan that will carry him safely into the 21st century. Politicians can learn a lot from him. He should manage a campaign.

—Hal Buell,
 July, 2000

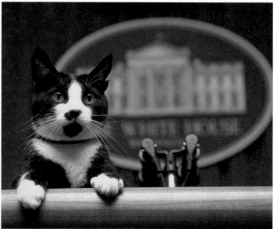

PHOTO OOPS

Photo Ops, aka photo opportunities, are a staple of political management. Photo Oops, on the other hand, are photo ops gone awry. *Photo Oops* throws a new light on politics. An explanation is required.

A photo op is offered to the media by the manager of a politician or a political campaign. The media is advised to be here or be there and to bring their cameras. The campaign manager hopes that a picture of a favored politician doing something picture-worthy will advance the campaign and move him or her closer to elected public office. Campaign managers are crafty and manipulative but even the most devious can sometimes arrange a photo op that becomes a photo oops. As TV news anchorman Dan Rather observed, "The camera never blinks." It will capture the good with the bad, or the bad with the good, as the case may be.

The photo op can be classified. In the interests of a better educated electorate we have tried to include examples of the following categories:

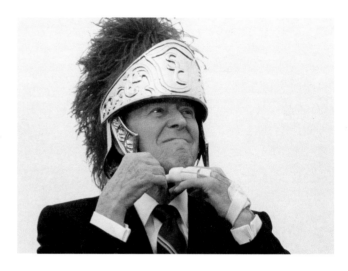

cians choose children's toys—REAL children's toys. Politician have never provided an explanation for this challenge of tradition but ample evidence exists to support its truth. The inescapable conclusion is that politicians must be happier reliving the simple joys of childhood than indulging in the more sophisticated fun seeking of most adults.

Boys And Their Toys

There is a popular ditty that goes like this:

> The difference between
> men and boys,
> Is the price
> of their toys.

That is true of actors and sports figures, tycoons and entrepreneurs, and those in arts and letters. Politicians, however, are different. They do not adhere to this ancient philosophy. When they play with toys, politi-

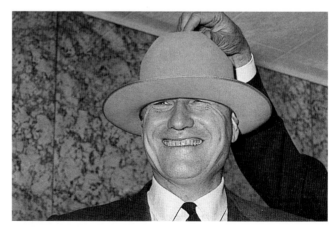

Campaign managers believe toys go over well with voters—things like toy airplanes, yo-yos, rubber alligators, a jack-in-the-box. Politicians love them all because every toy—every child's toy—brings a new delight into the life of the campaigner.

When receiving such a gift, the politician will proudly display it for all to see. There is no shy reluctance for the adult office-seeker to accept such gifts or to conceal his or her liking for children's toys. Every day is Christmas to the accomplished politico.

Politicians and Babies

Politicians are drawn to babies with the inbred instinct of a salmon heading home. It has been that way always. Why politicians act this way remains a mystery, because babies more often cry than coo when cuddled by a politician. And the responsible voter has to ask: Would an intelligent adult hold a strange child more likely to throw up mashed peas and carrots than smile?

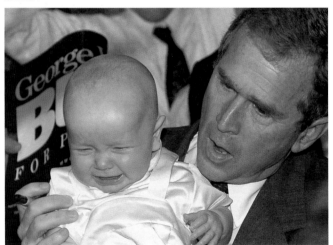

Consider further: Babies are cute whether they coo, scream, cry or throw up. In comparison the politician is not! Why get into a cute contest?

Any actor with more than an hour of experience says that children upstage the adult performer. The wise thespian avoids acting with them.

Still, day after day, politicians seek the company of children in their bid for votes. But why? The kid can't vote, the parents are interested in getting a picture of their child with the politician in the paper (another mystery) and those who see the picture wonder why the politician isn't talking to people who can reduce the national debt. It's a losing proposition from the start.

But politicians and babies remain inevitably linked. Like bread and butter, like cup and saucer, like Frick and Frack, they have been together throughout history.

The Political Handshake

The political handshake is instinctive to politicians.

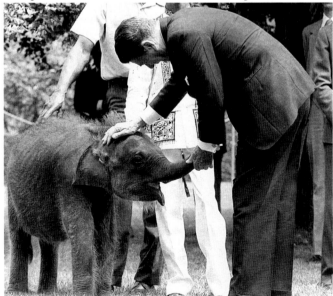

The handshake starts deep in the belly of the office seeker, ignited by the sight of any nearby hand otherwise unoccupied.

This handshake will, in practice, grip the hand of man, woman, child or infant. It will also reach out to the extended paw of a dog or the trunk of an elephant or any appendage that resembles a hand. Despite pain from repeated handshakes, the instinctive process ignites itself repeatedly in a meaningless flurry. There is no pain barrier to the experienced politician faced with handshake potential.

In popular parlance this is called pressing the flesh though that is a misnomer. Frequently the handshake is reduced to barely a touch; there are so many hands to shake but so little time.

Politicians and Critters

Next to babies, the politician's greatest attraction is for critters and other, larger, four-legged beasts, preferably but not exclusively of the barnyard variety.

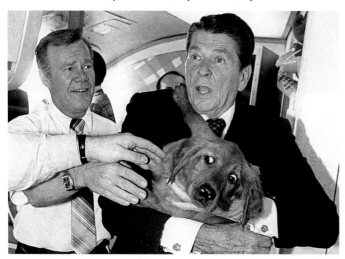

If the critter is small, politicians hold them, cuddle them and treat them much like babies. If the critter is large, politicians ride them, herd them and shake their paws, trunks, hooves, etc.

Pundits may say that a connection with critters will show the politician to be a good guy, salt of the earth, regular fellow. Farmers, however, will tell you that you do not cuddle baby pigs. They may pee on your vest and that would be embarrassing. Baby pigs are meant to be fattened and sent to market, not cuddled like a pet cat.

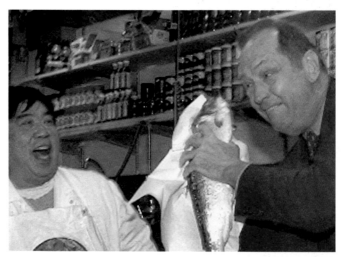

Politicians like to be photographed with dogs. This is more reasonable, for who dares to deny that a dog is man's best friend. Just about every president has had a dog, a few of which have been involved in national controversy. The dogs always won, which is more than can be said for the politicians. It is understandable that politicians would want to be seen with proven winners. Still, dogs and pigs together could not carry the third ward in Chicago.

Politicians and Other People's Clothes

Most politicians possess formidable wardrobes, but that does not prevent them from wearing clothes meant for other people

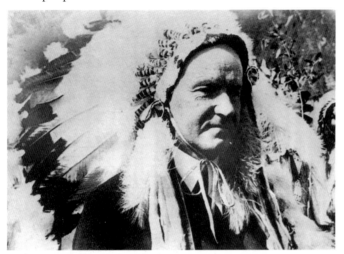

Why a politician dresses in drag opens a line of discussion that would delight Sigmund Freud. The explanation, however, is best not included in the exposé offered in this volume. This is, after all, a family book meant to educate, not titillate.

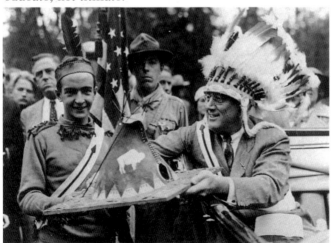

Image makers are people who politicians hire to change their appearance. Image makers are paid fantastic salaries to guide the office seeker's proper selection of wardrobe. The image maker creates a model that promises to inspire voters to pull the right lever on election day. Once decided, however, the politician discards the costume so carefully designed and opts for a cook's apron, the studded leather jacket of a Hell's Angel or military garb of the kind used by Navy SEALS or Green Berets.

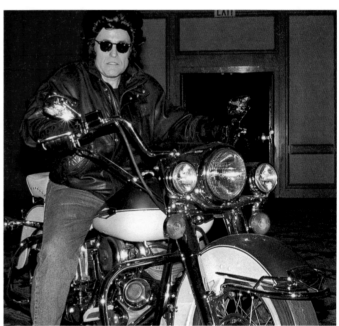

We are told that clothes make the man. If true (and who would doubt the wisdom of the ages) the politician's fashion taste resembles a kind of crazy quilt, patched here with a print, there with a plaid, and over there with an old sheet worn in the center but usable on the edges. Whatever costume works is the one used, but would you cast your ballot for a person who one day is a deli sandwich maker and the next a Bhutanese archer?

The Political Gesture

It is a cliché, but there is no other way to say it: Politicians love to point with pride. The grand political gesture is the political orator's flesh and blood punctuation mark.

They point this way and that, up and down, to the right and to the left.

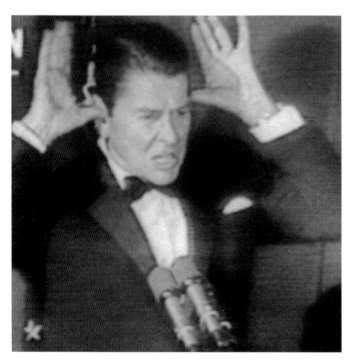

More attention goes into the thrust of their arms than into the words they choose.

Their gestures sweep across the podium the way the great plains sweep across the midland. Politicians believe that a well-timed gesture can explain the intricacies of a complex issue even though the gesture frequently distracts the listener. Perhaps that is its purpose.

Politicians also believe that gestures tell the audience that the politicians comments come from the depths of the heart. The gesture confirms that his message is for YOU, and YOU alone.

Not all gestures are so forceful, of course, and some miss the target.

But no gesture was ever as direct, as unmistakable in its meaning, or as clear in its message as Nelson Rockefeller's Binghamton, NY, sign to the multitude. Now there was a man who knew what he wanted to say.

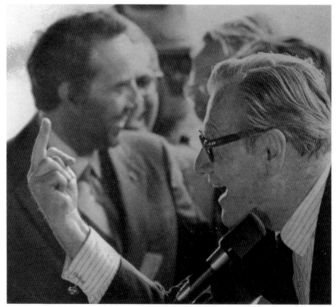

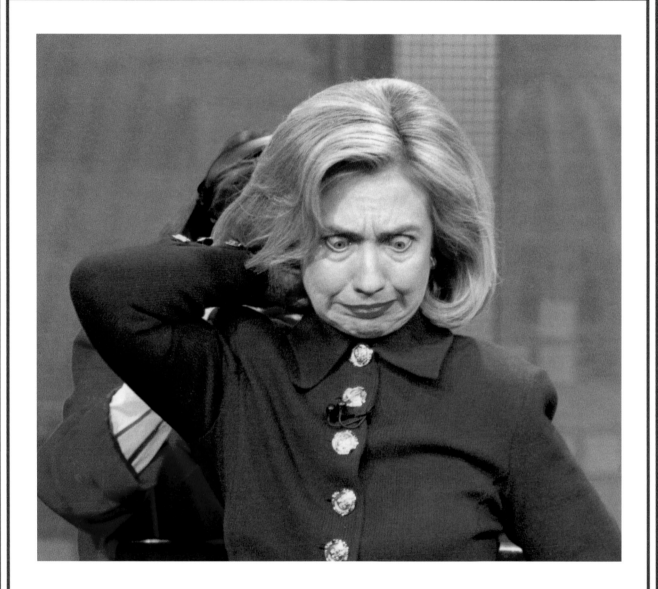

To win an election it sometimes helps to be a contortionist.

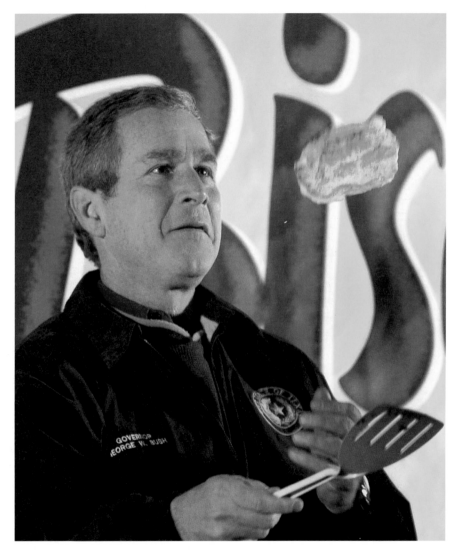

"I have come to the International House of Pancakes, today, to talk about foreign affairs."

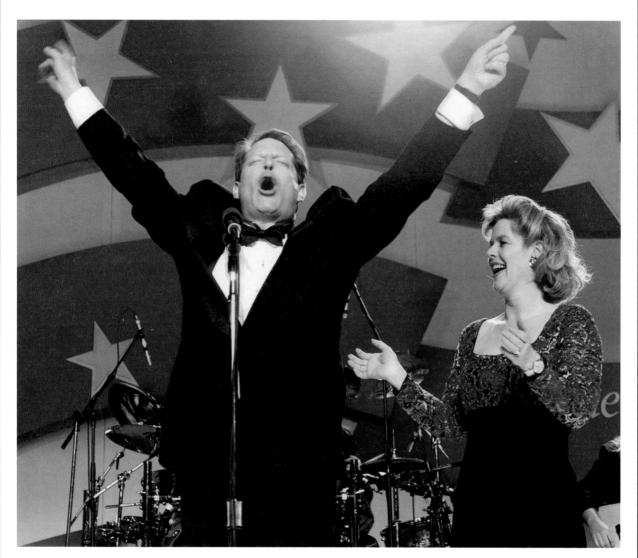

"Al, we said relax. You don't have to go bananas."

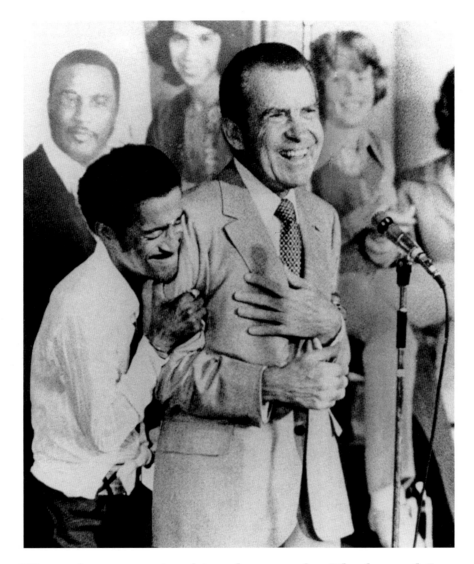

Nixon demonstrating his tolerance for Blacks and Jews
at the same time.

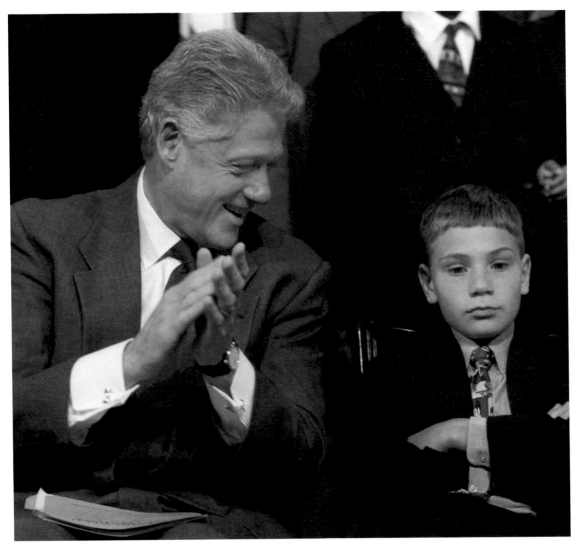

"And if you contribute more than $25,000 you get to sleep
in the Lincoln bedroom."

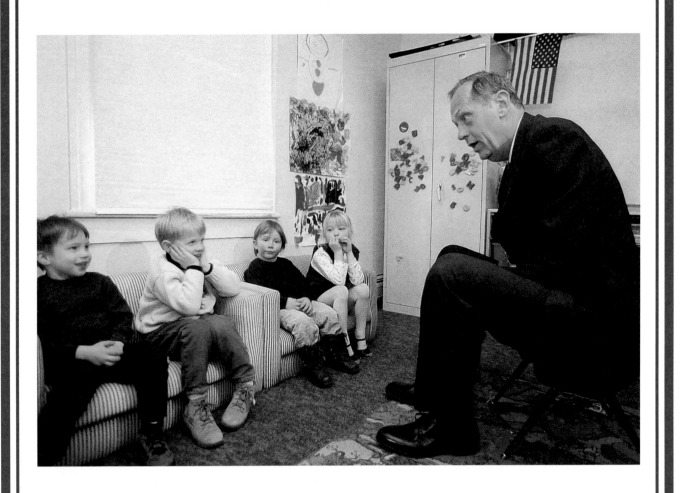

"Did I mention that I used to be a New York Knick?"

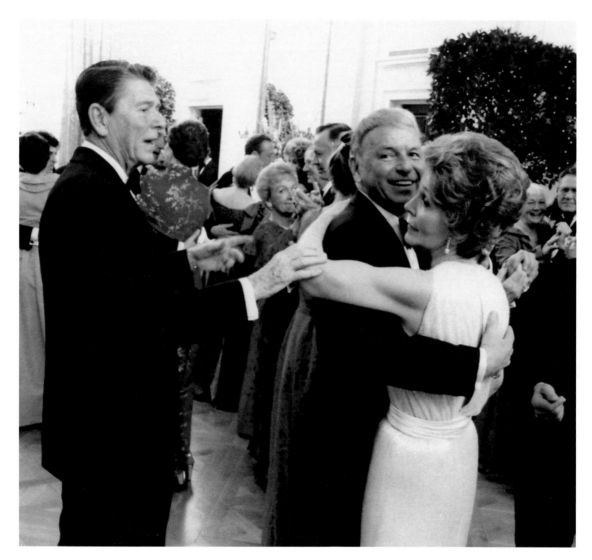

"I'm sorry Ronnie, you may be President, but Frank is
the Chairman of the Board."

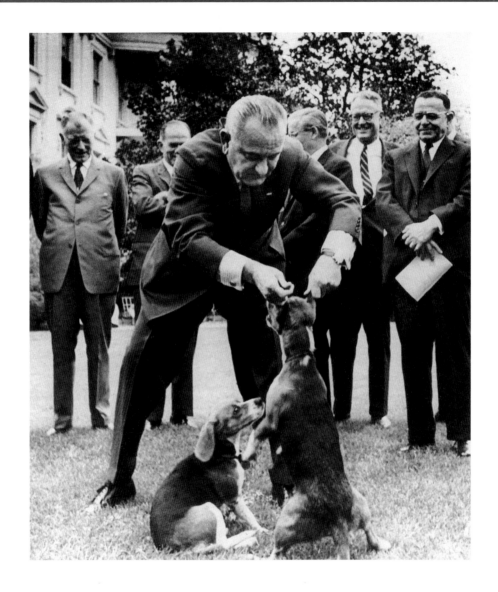

"All my cabinet members stand at attention."

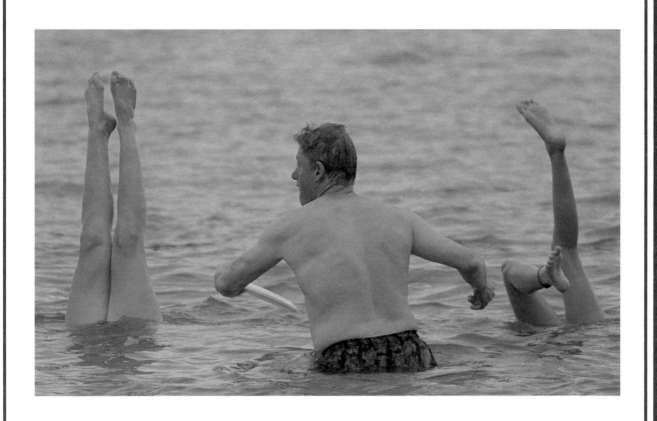

"Honest to God, Hillary, it was just me and a couple of my closest advisors on the Honolulu trip,"

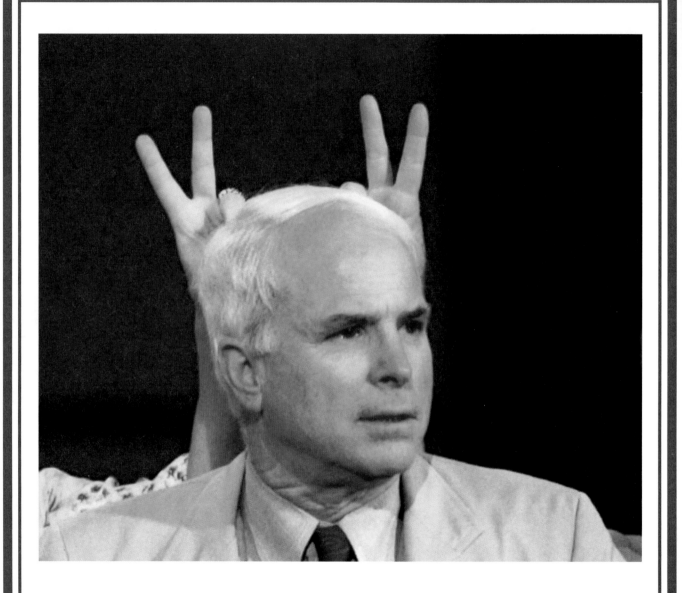

"No, why would you think that the religious right wishes me any ill?"

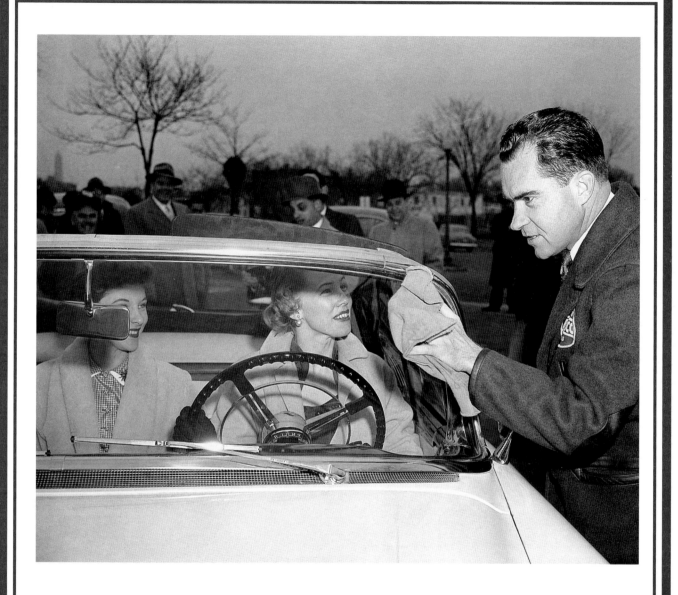

In the pre-squeegee law days, Nixon would do anything for a vote.

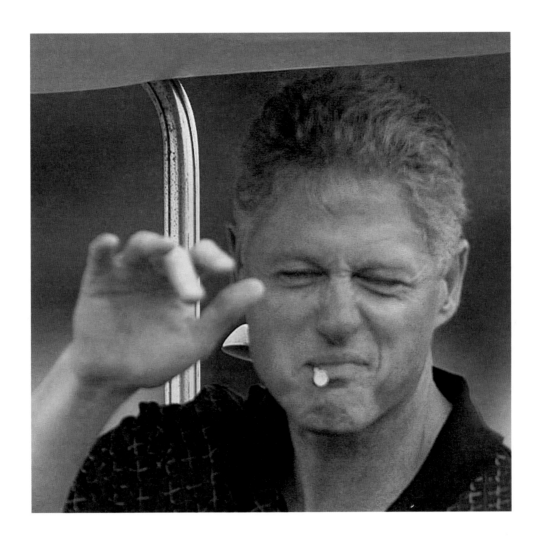

Close, but no cigar.

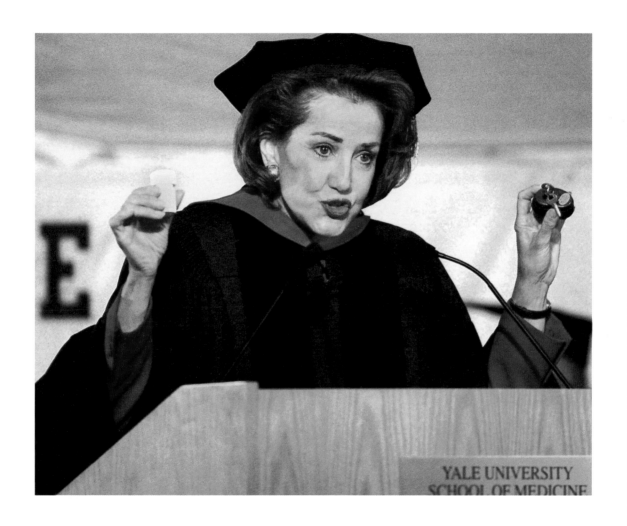

"Yes, Viagra *is* a miracle!."

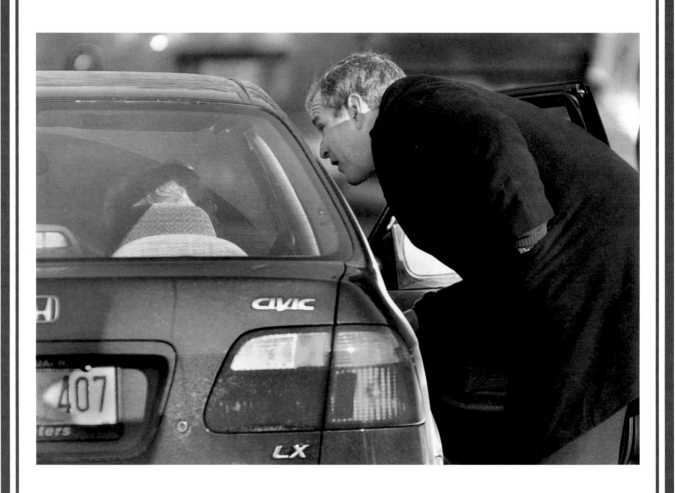

"Pleeze, won't you give me a ride. I really have to pee."

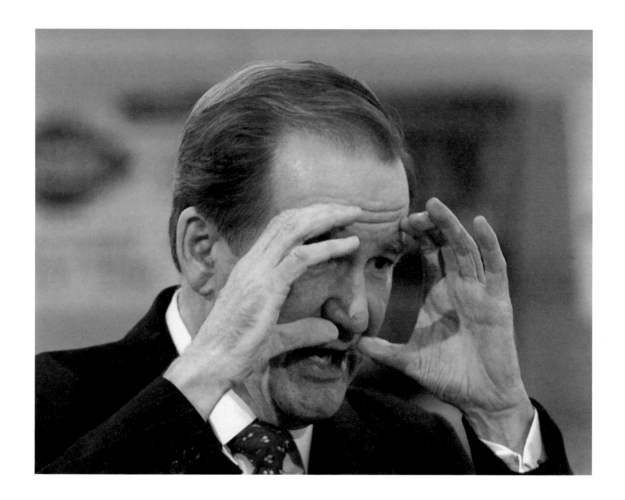

"Our goal is to make our minds smaller and smaller."

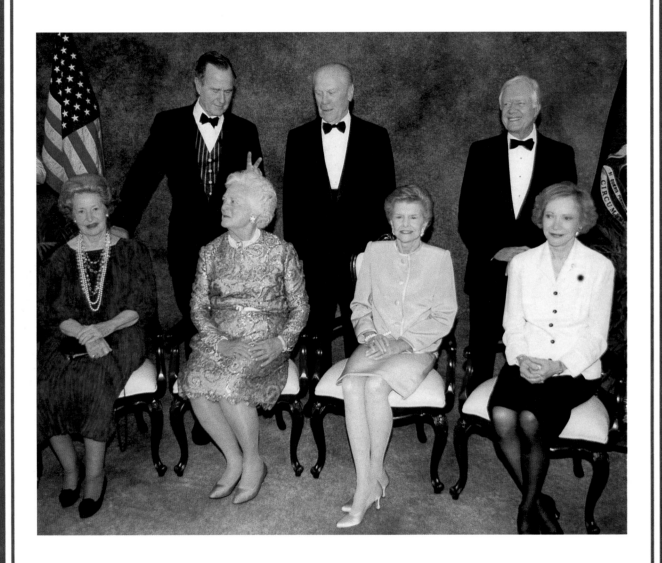

Life of the party.

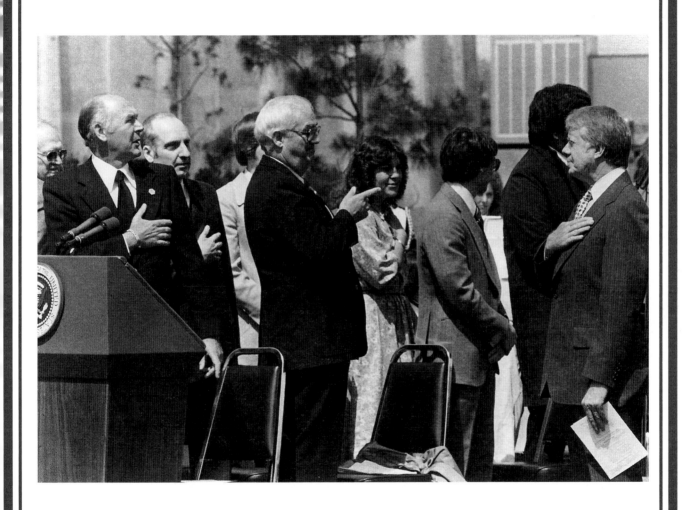

"That way, Mr. President. The flag is over there."

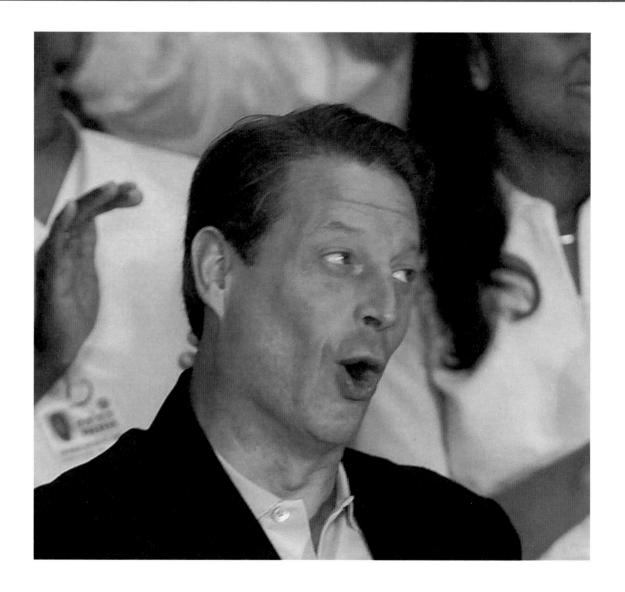

"Oh yes, we had a few puffs, back in the sixties."

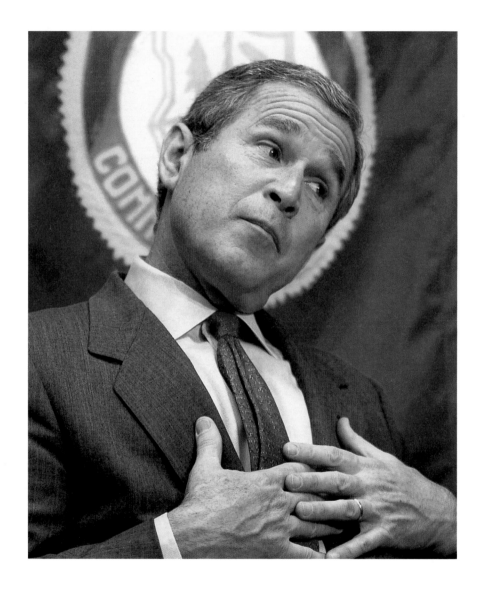

"It depends what you mean by 'drugs.'"

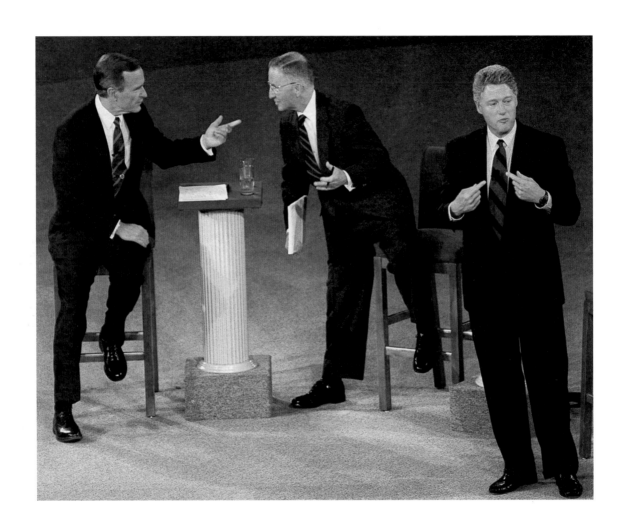

"Yada, yada, yada."

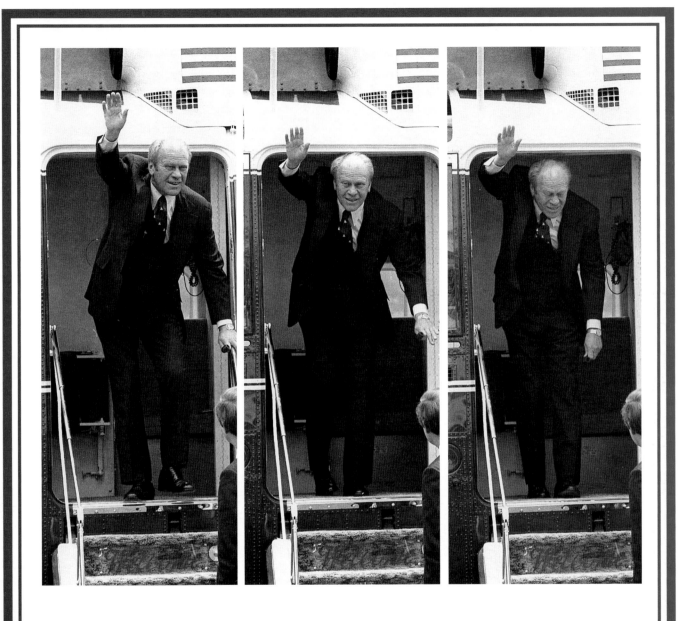

President Ford learning how to board Army One.

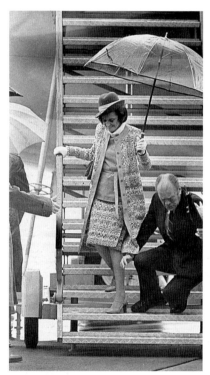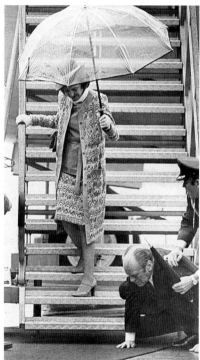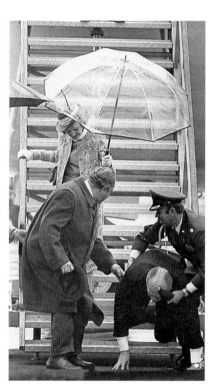

President Ford learning to use the stairs on Air Force One.

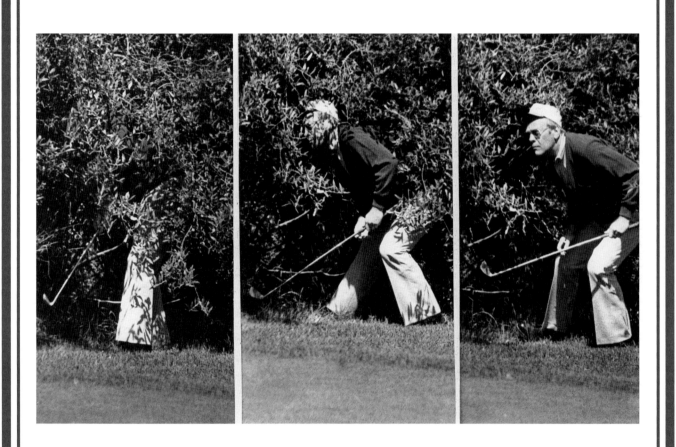

President Ford learning to play golf.

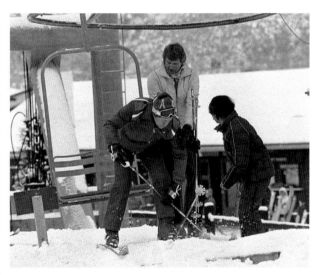 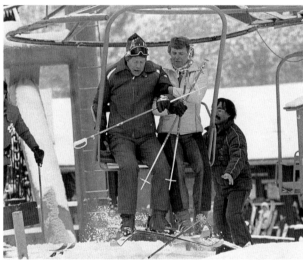

President Ford learning to ski.

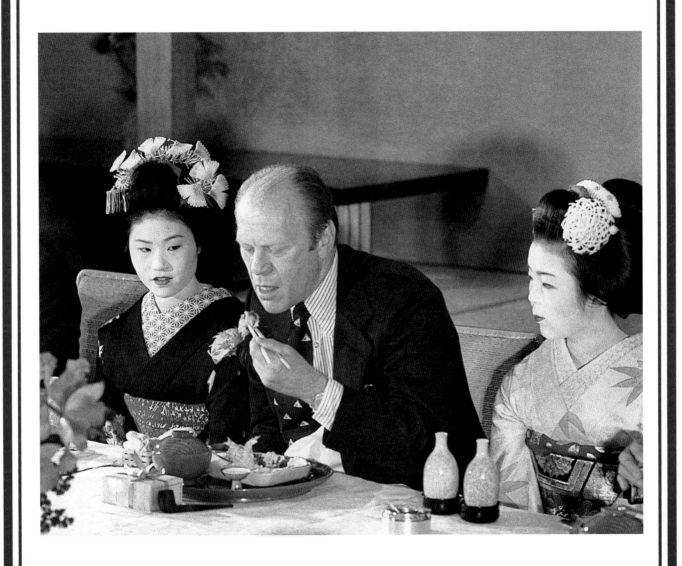

President Ford learning to eat.

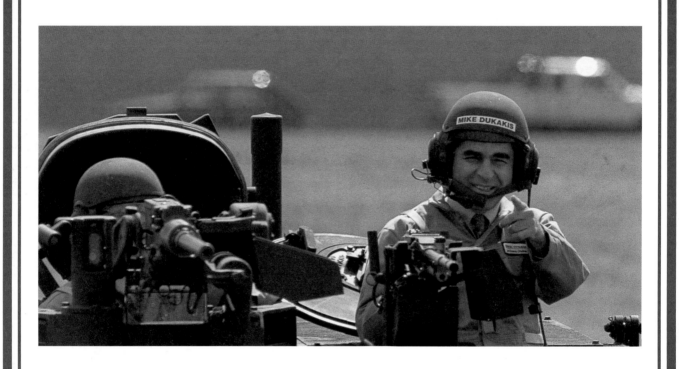

Snoopy for president.

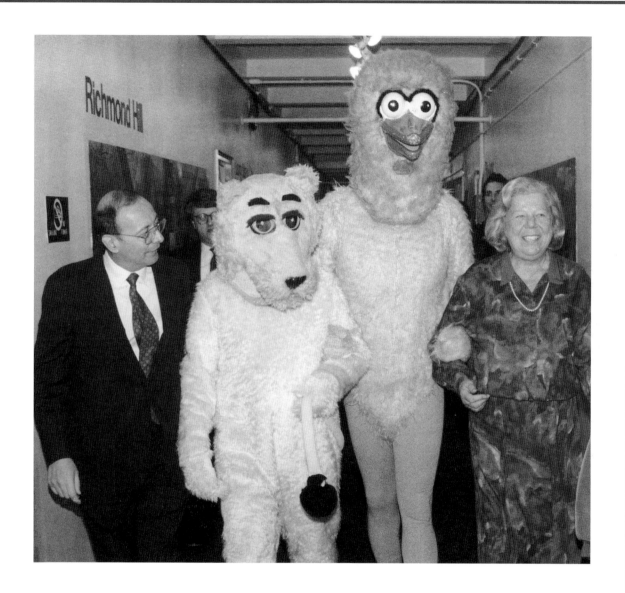

Al D'Amato and his brain trust.

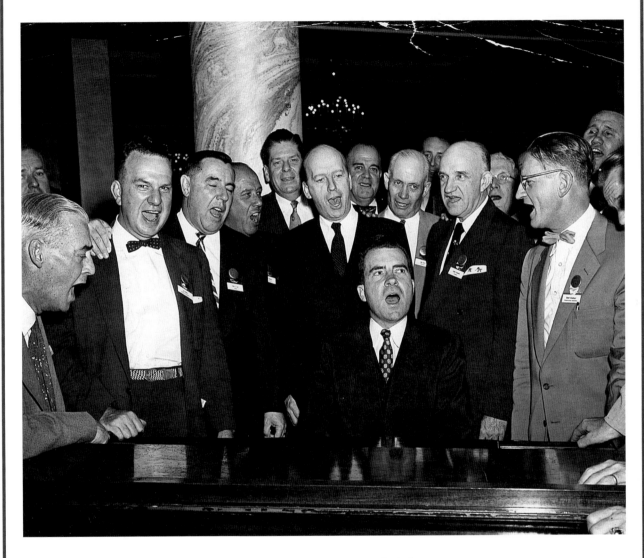

"For he's a jolly good felon,
For he's a jolly good felon..."

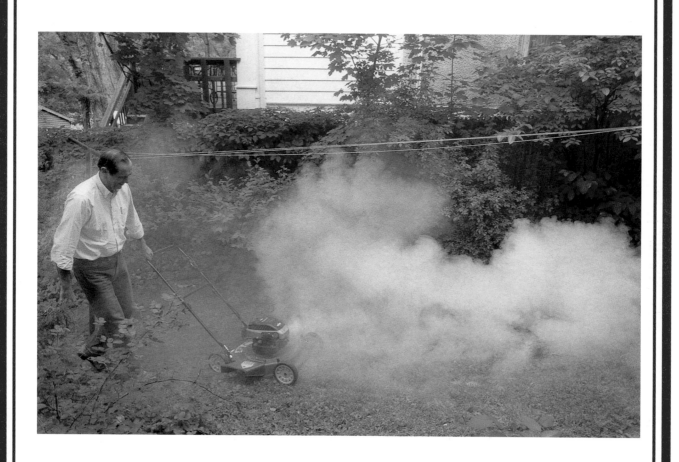

Mr. Environment

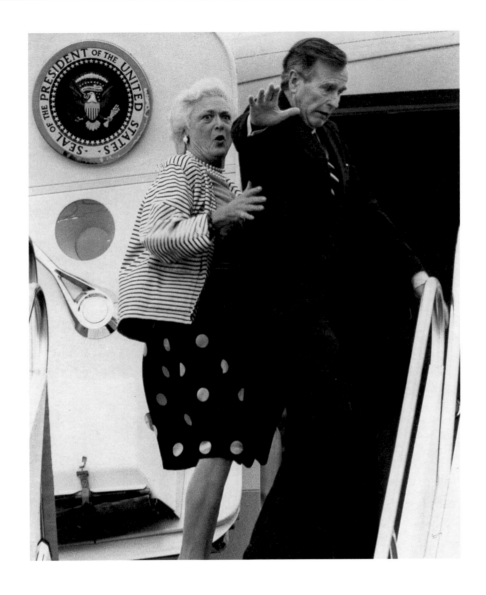

"Oh George, stop doing that Jerry Ford imitation again. It's not funny."

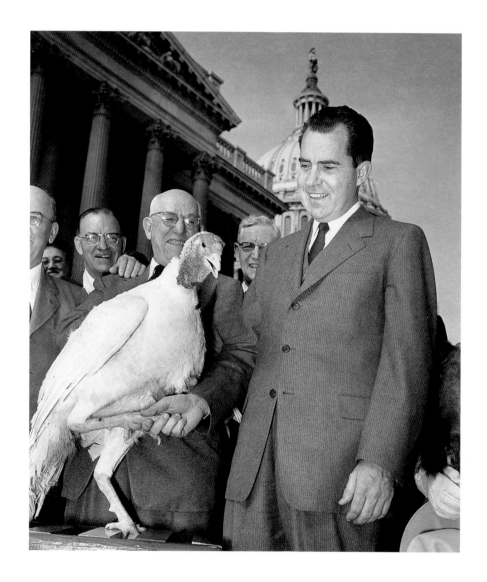

"I am <u>not</u> a cook."

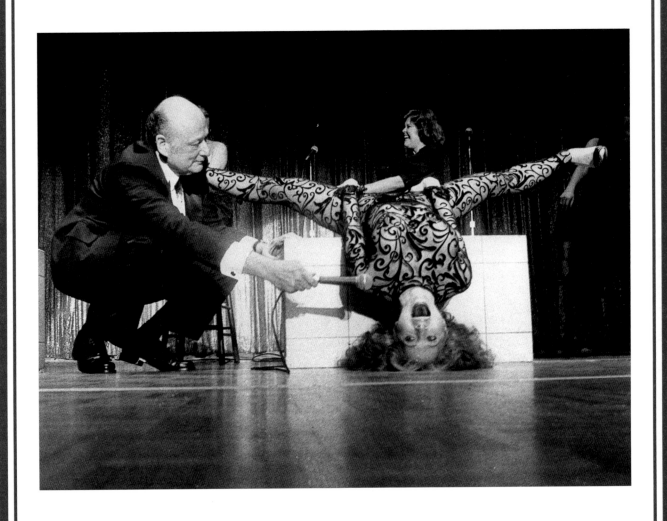

Ed Koch going after the split vote.

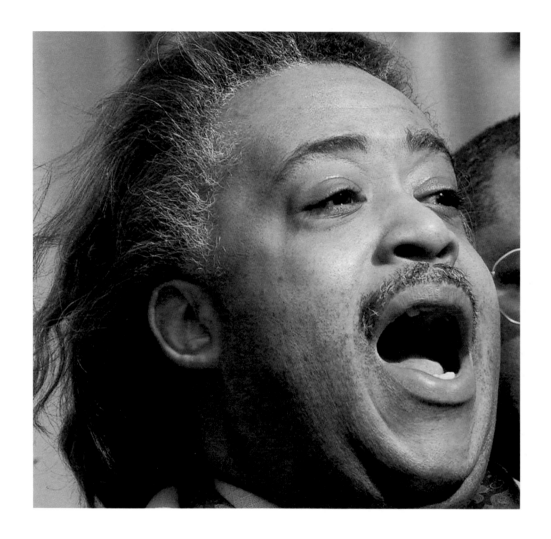

Oh, shut up.

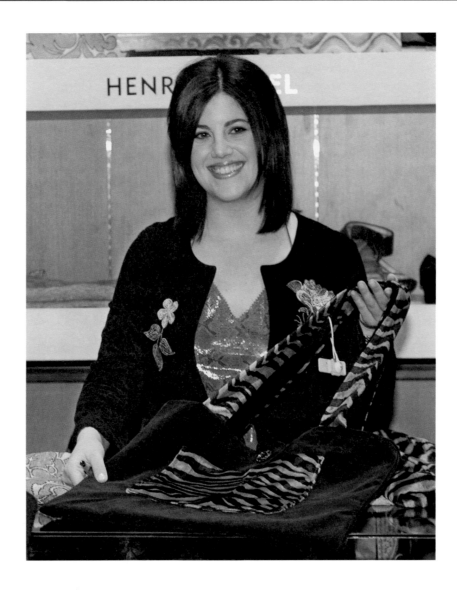

"And this fabric doesn't show any stains."

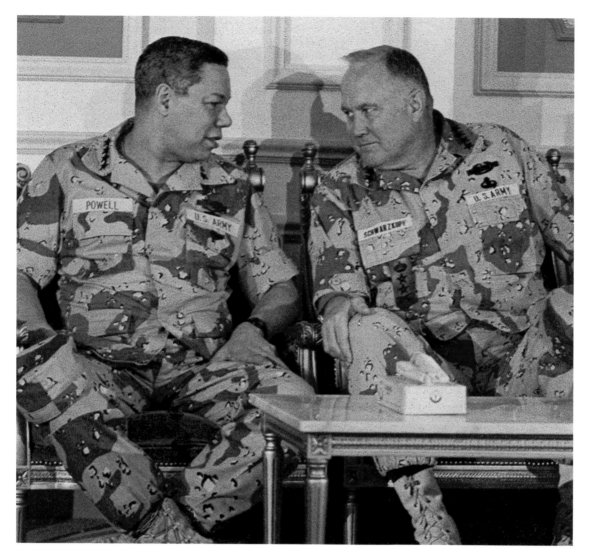

"I thought you said you we're going to wear the khakis,
not the desert fatigues. Now look at us!"

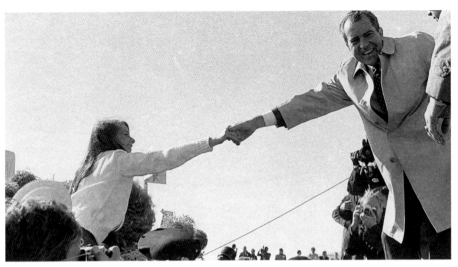

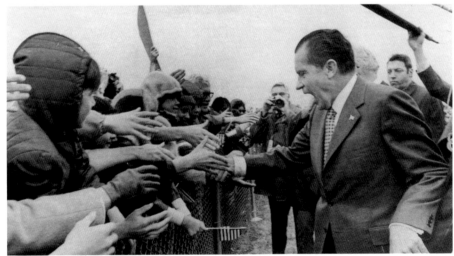

"Oh, how I love to get out, to meet with the American people, and to get close to them."

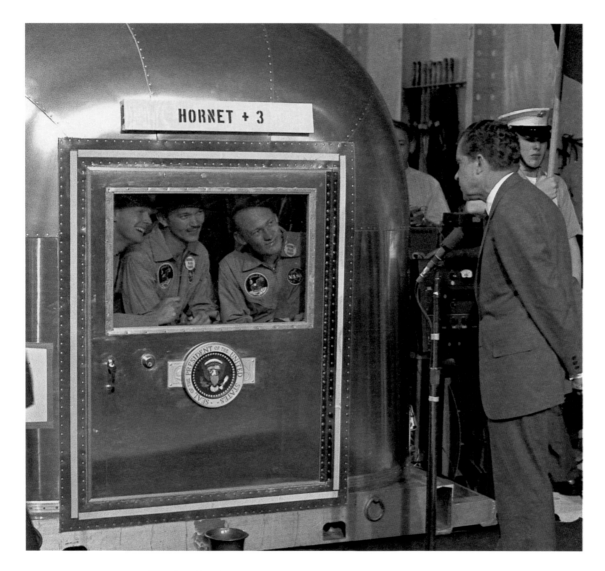

"You guys still think those Watergate jokes you made are funny?"

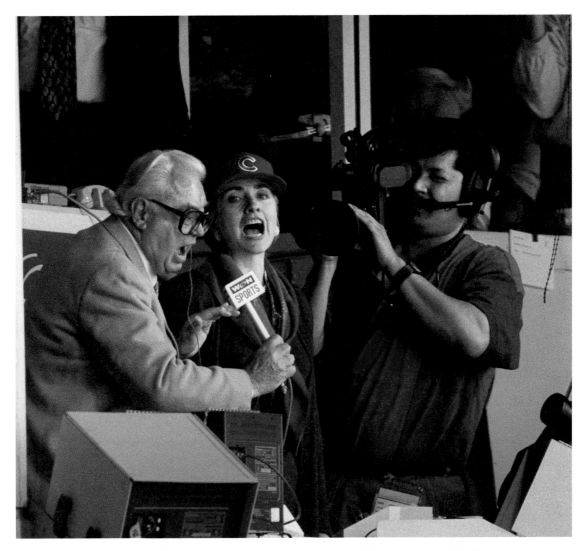

"Let's go Cubs! No I mean... Let's go Mets... or Yankees...
depending...whatever."

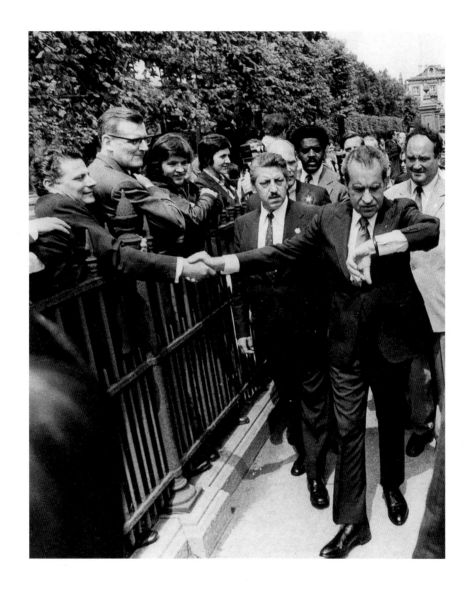

"Hi, nice to meet you. Hi, nice to meet you. Hi, nice to meet you..."

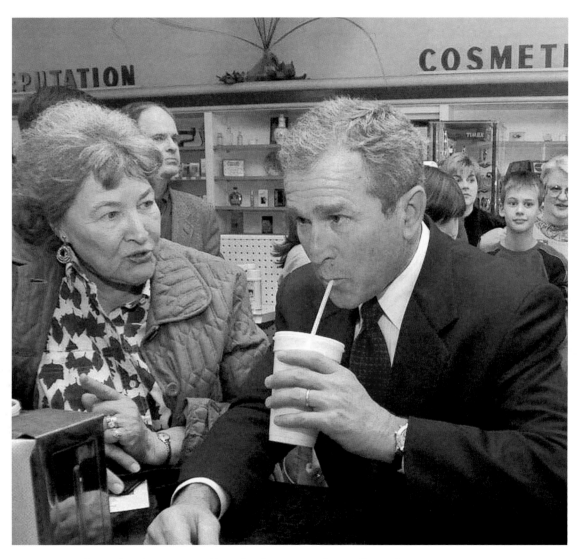

"You don't remember? It was after that fraternity party.
She's all grown up now and she looks just like you."

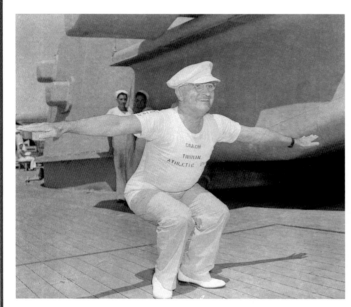

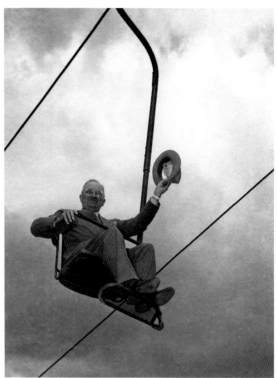

If God had meant presidents to fly, He would have given them wings.

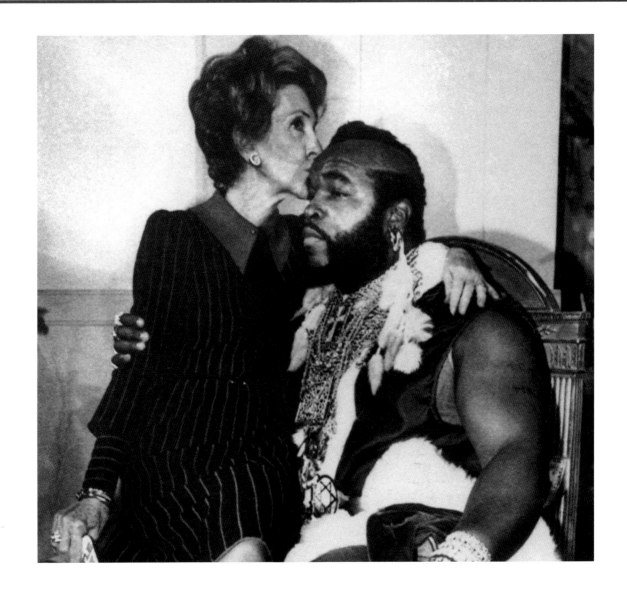

"Ronnie just doesn't understand me."

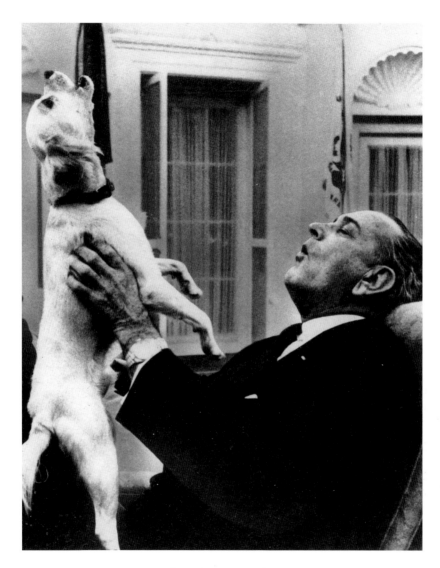

"The doggies howl,
deep in the heart of Texas."

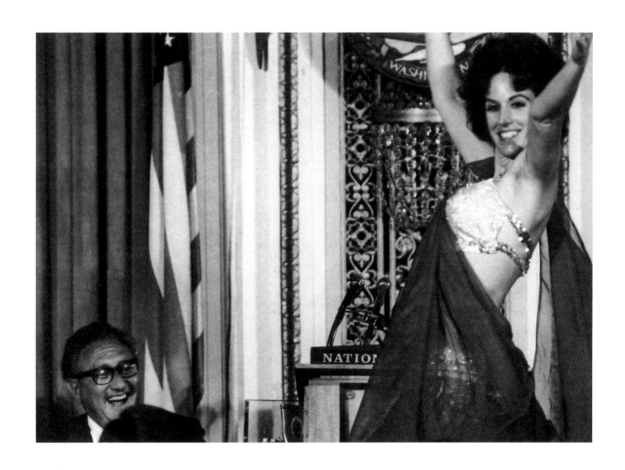

"I wonder who's Kissing-er now?"

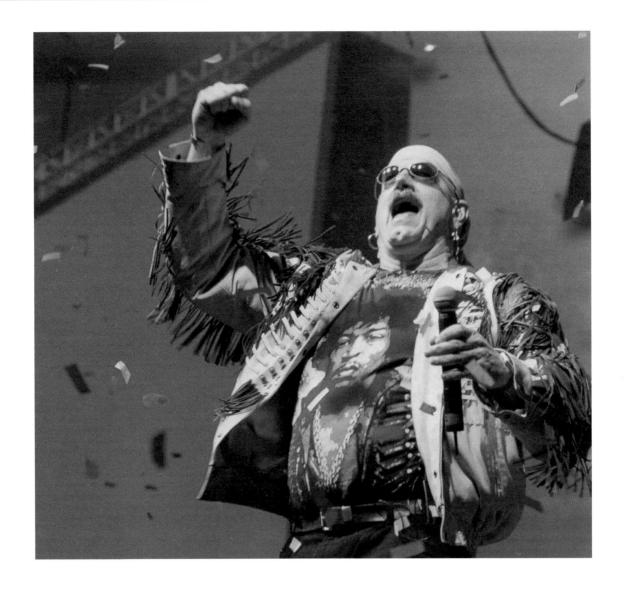

"I'm out of the Reform Party because Buchanan is just too wierd."

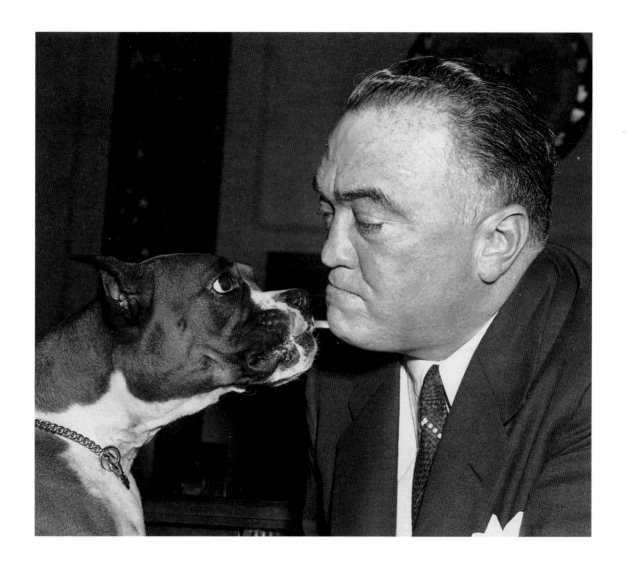

J. Edgar Hoover and his bitch.

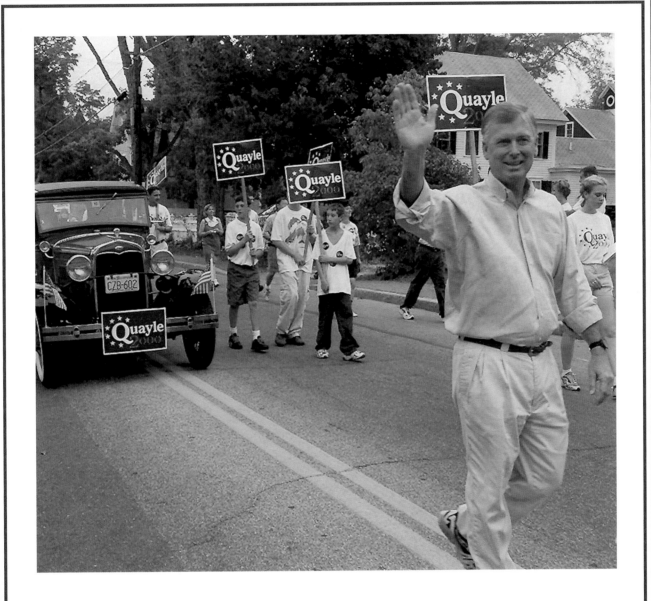

Dan Qwail four prezident.

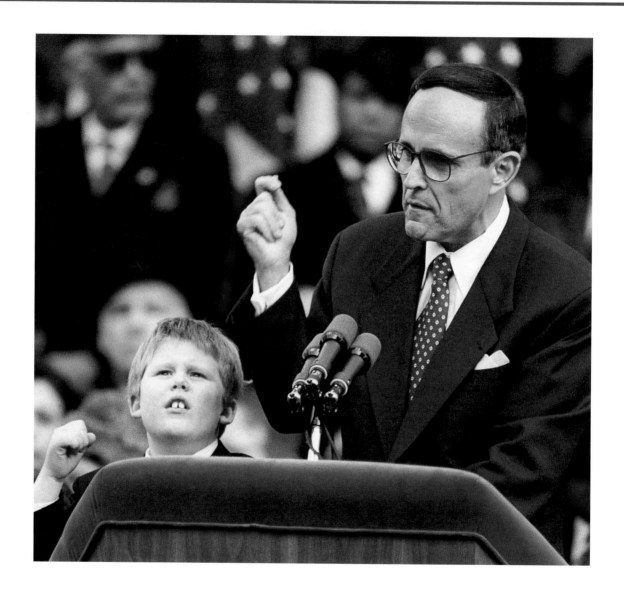

"Dad, follow my lead."

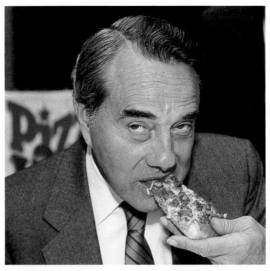

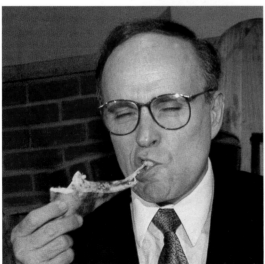

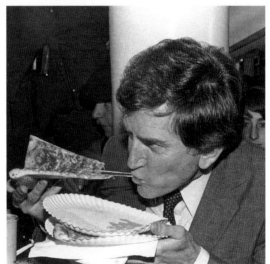

Courting the pizza guy vote.

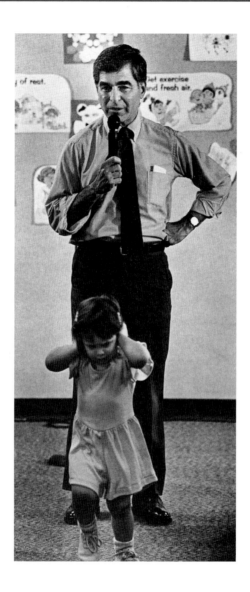

Dukakis's policies appealed to very few.

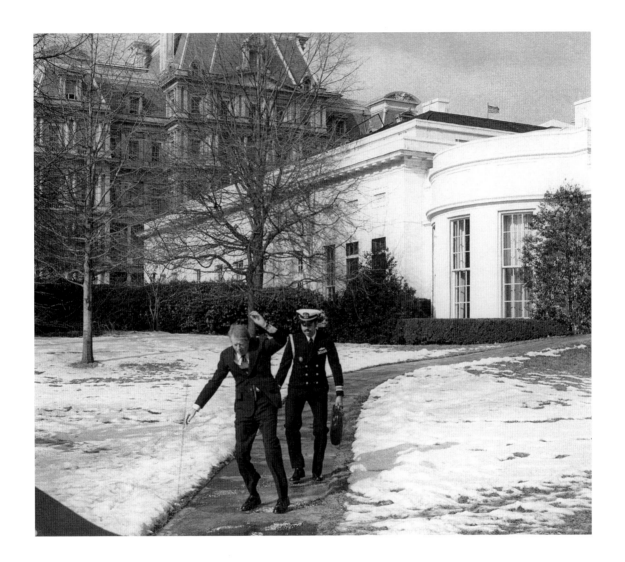

Jimmy Carter slipping away from the White House.

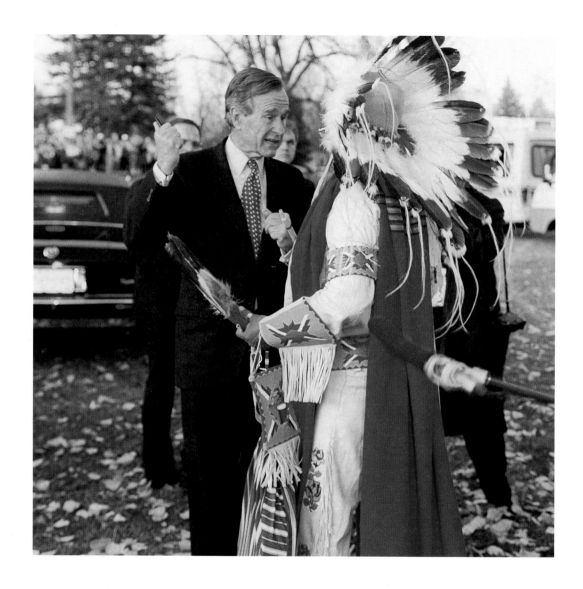

"No, no. Thanksgiving is at my house this year."

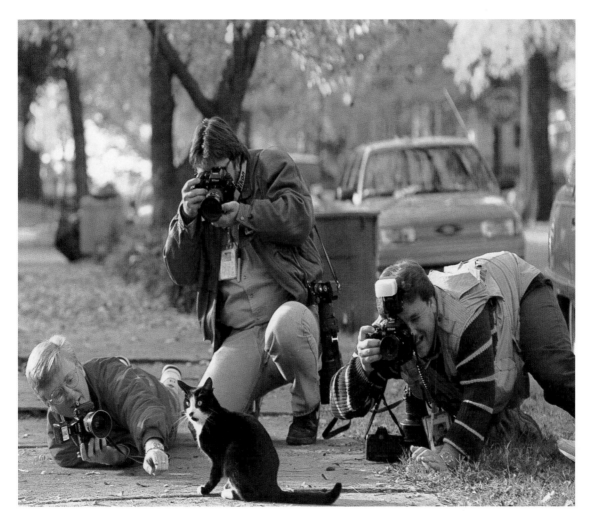

After eight years in the White House,
Socks learned to ignore the paparazzi.

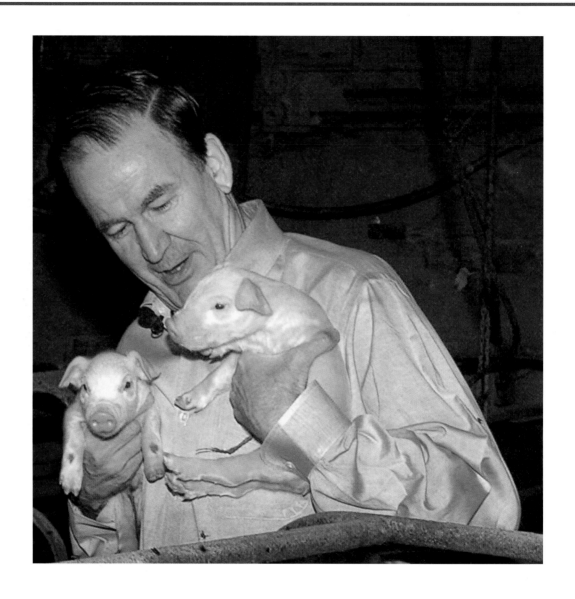

"Okay, let's poopoo on his shirt."

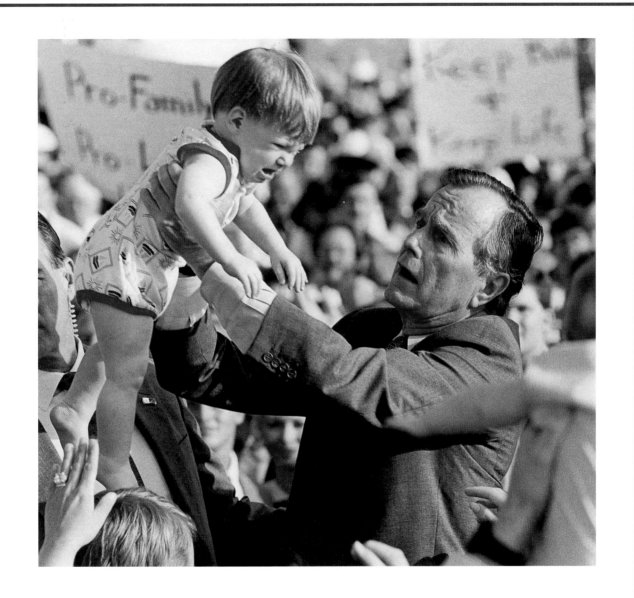

"I <u>am</u> kinder. I <u>am</u> gentler, dammit."

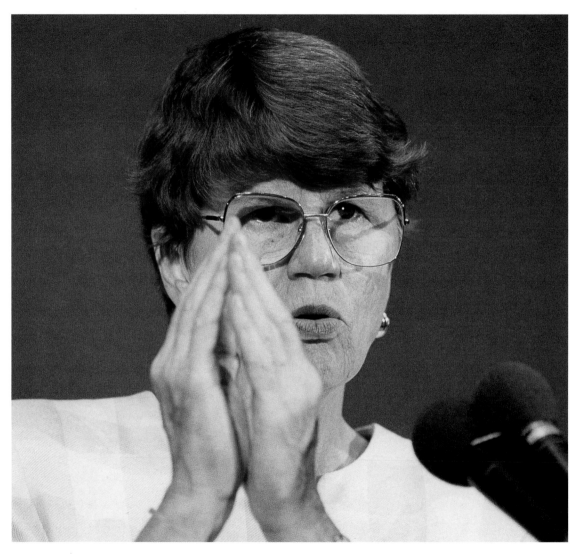

"This is the church, this is the steeple, open the door, send in the ATF troopers and firebomb the place."

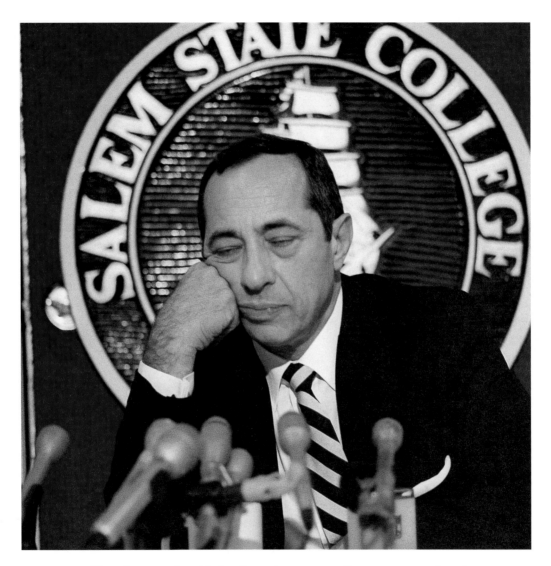

By the end of his fourth term, Cuomo got tired
of Cuomo's leadership, too.

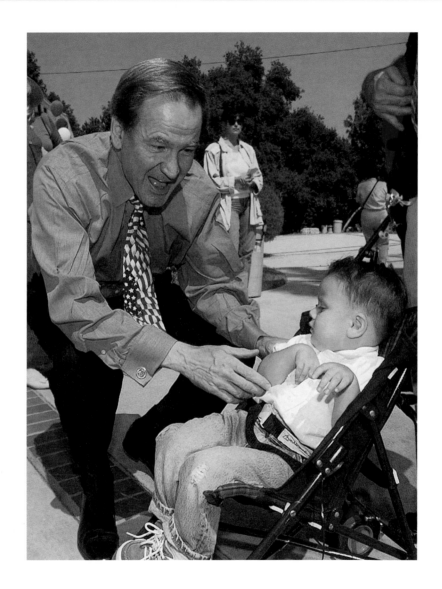

"Let's scare some kids."

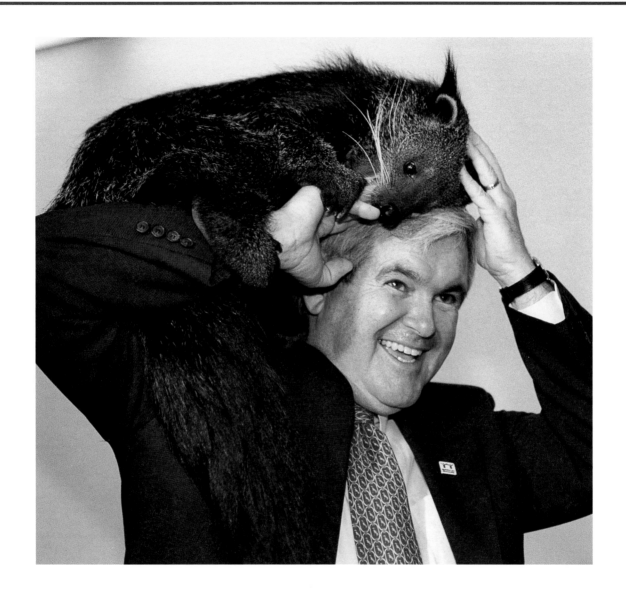

"I knew Davy Crocket, and you're no Davy Crockett."

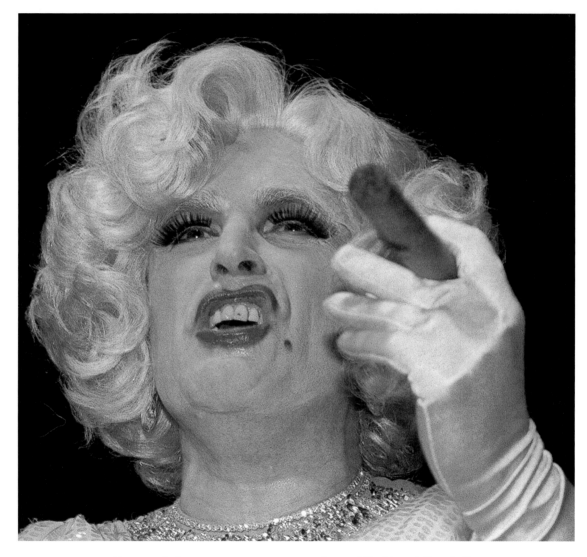

One of the many reasons that Giuliani had for
dropping out of the Senate race.

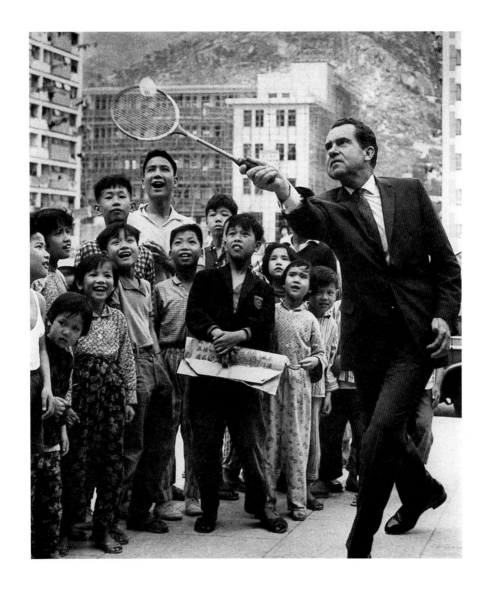

Nixon the athelete.

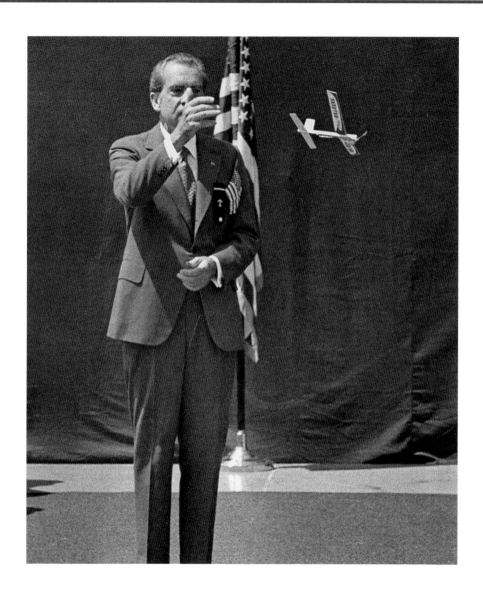

Nixon the aviator.

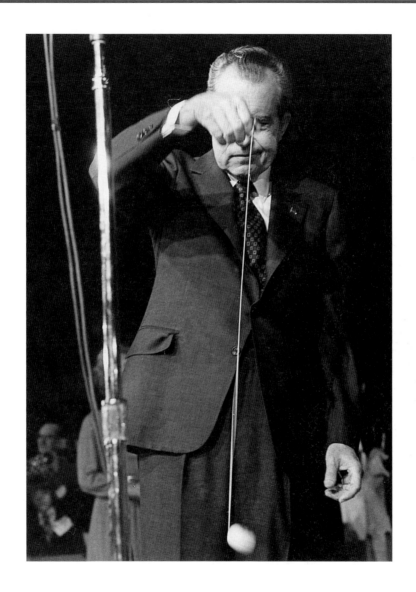

Nixon trying to get it up.

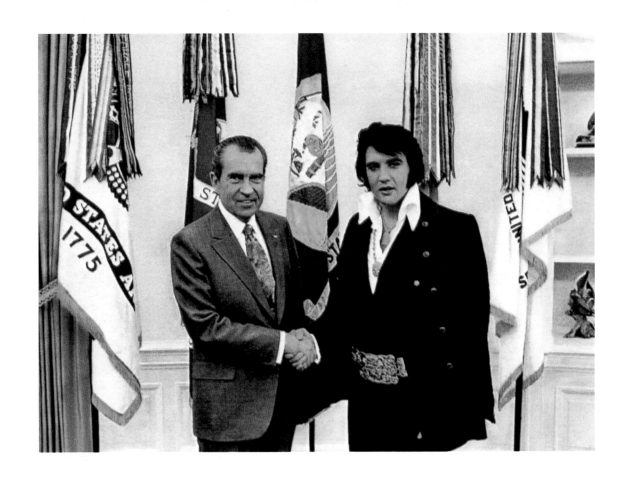

"So, you're the young fellow I saw on the Ed Sullivan Show, aren't you?"

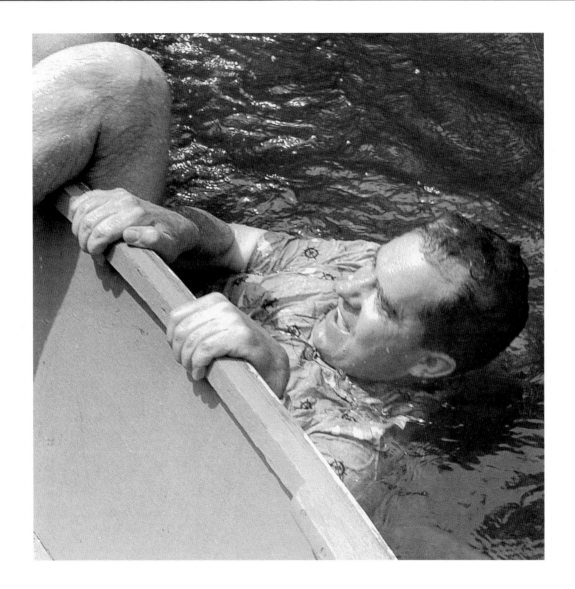

"This is a trick that Ted Kennedy taught me on Chappaquiddick."

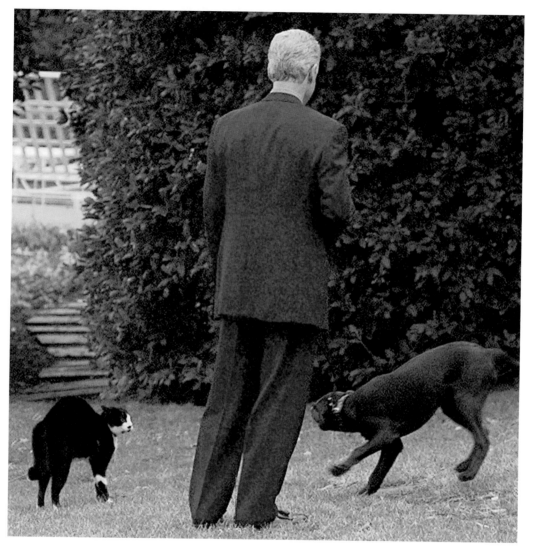

"Listen Buddy, Listen Socks, if I can't even get you guys to get along, how I'm going to deal with Congess?"

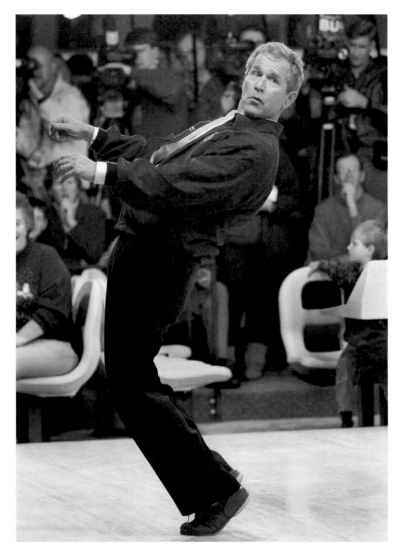

To get the nomination you lean to the right.
To win the election you lean to the left.

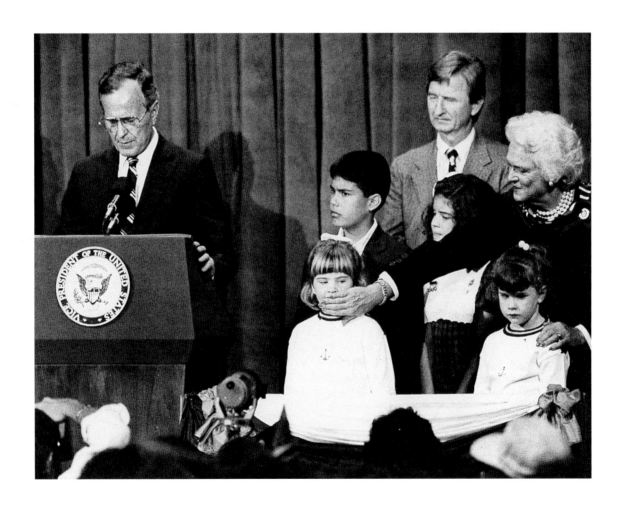

"No, no, no. Read <u>his</u> lips."

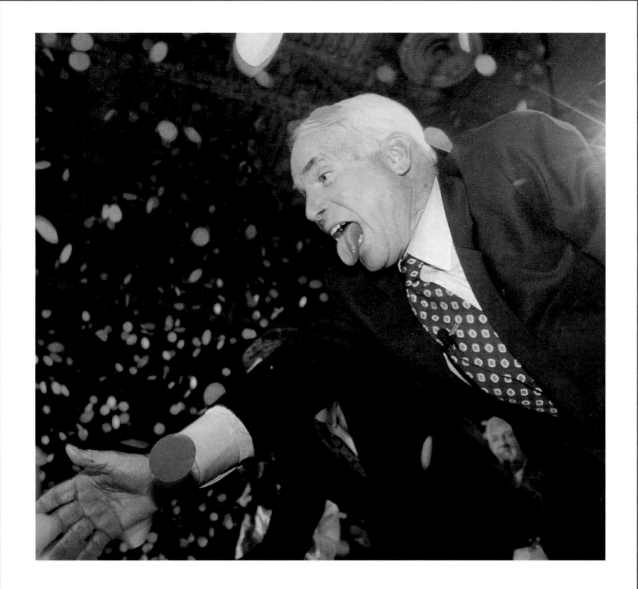

"Whazzup!"

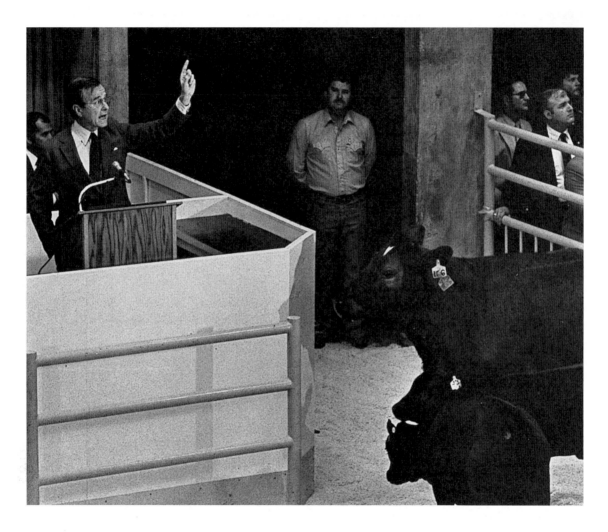

"I will stand by my position until the cows come home.
Whoops, gotta go."

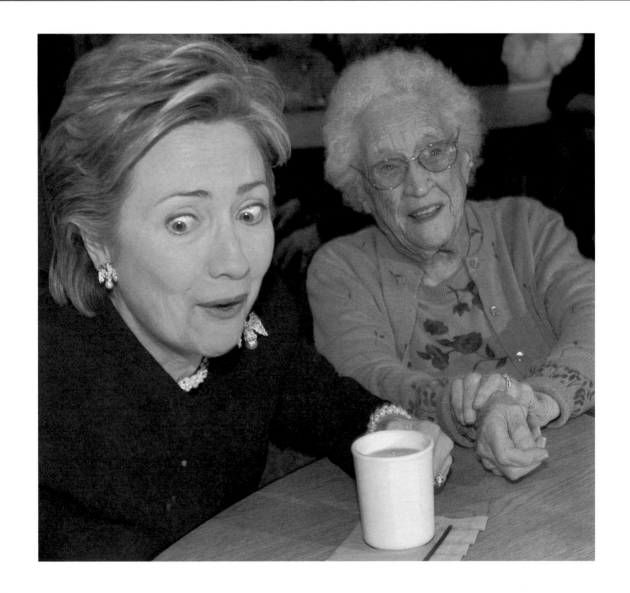

"Oh no, not you, too?"

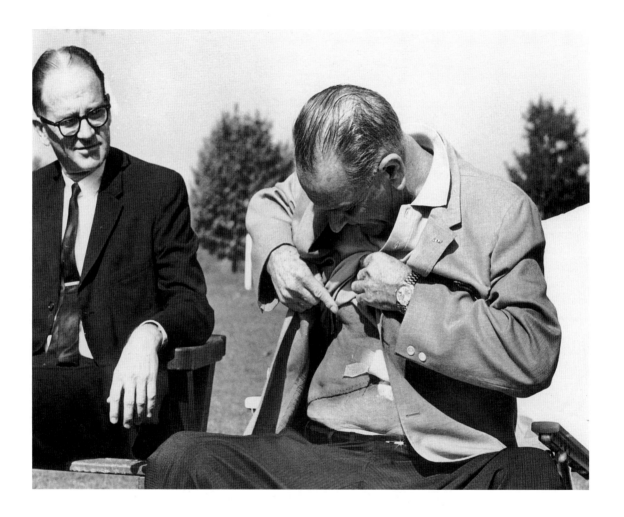

"And when Charlie comes down the Ho Chi Minh Trail here,
we'll nab him and kick him in the butt."

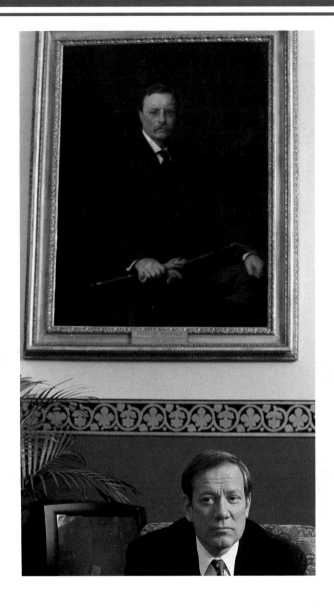

"I knew Theodore Roosevelt, and you, sir, are no Theodore Roosevelt."

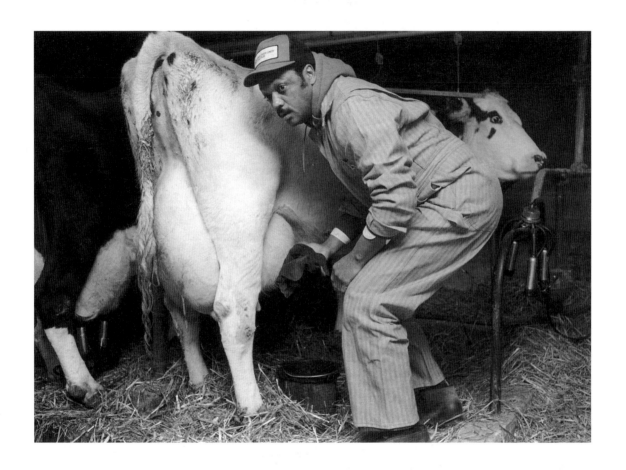

Jesse milking every opportunity.

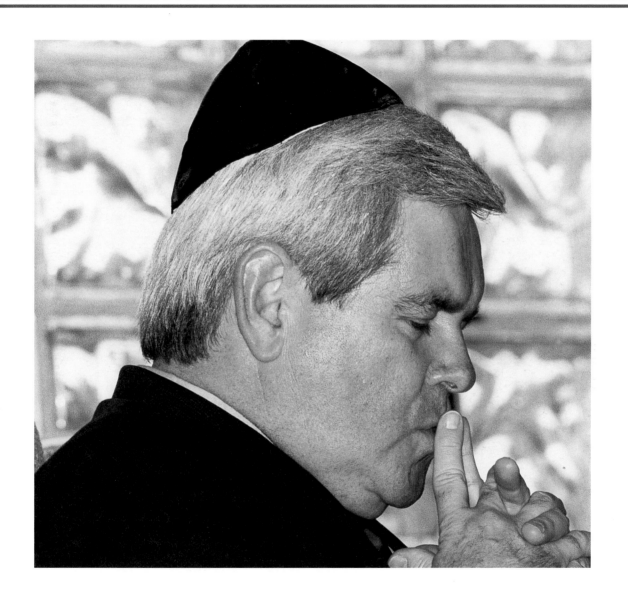

Rebbe Newt

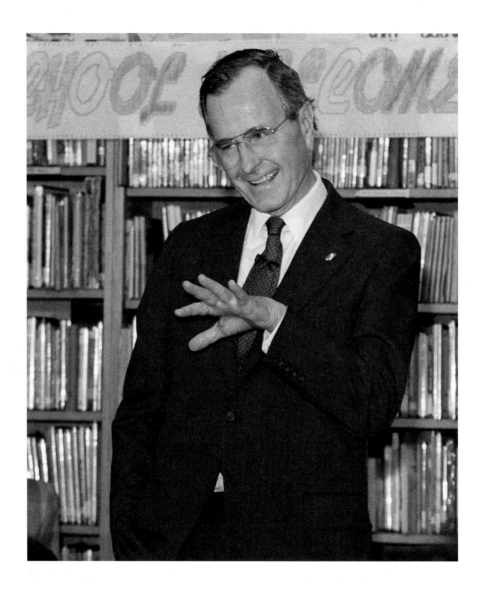

"No, when we were in the Navy, if they asked, we'd tell."

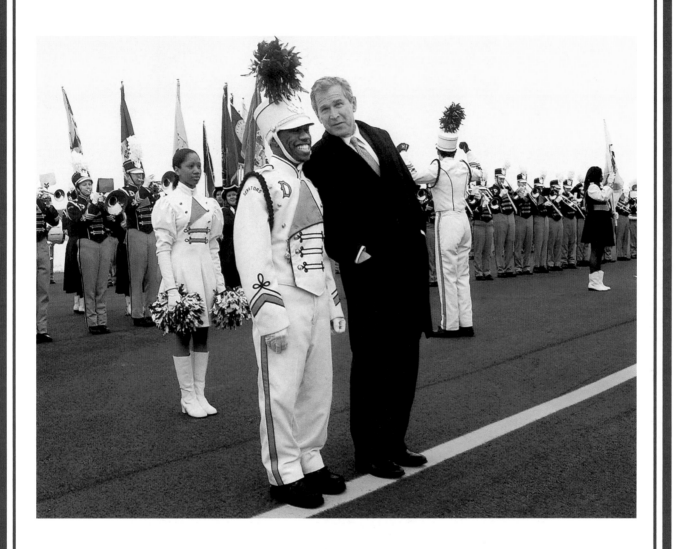

"Now that the Confederate flag is off the capitol building
in South Carolina, you'll vote for me. Won't you?"

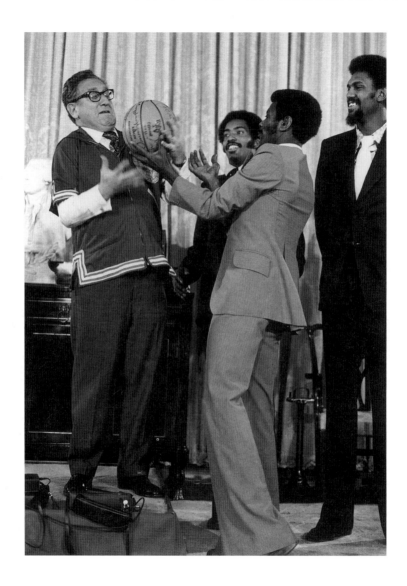

The Globetrotters meet another globetrotter.

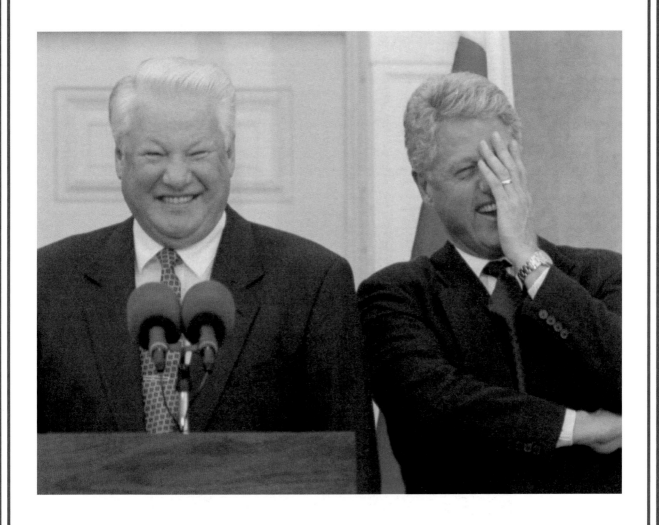

"And then there's the one about the Commissar and the Kremlin intern."

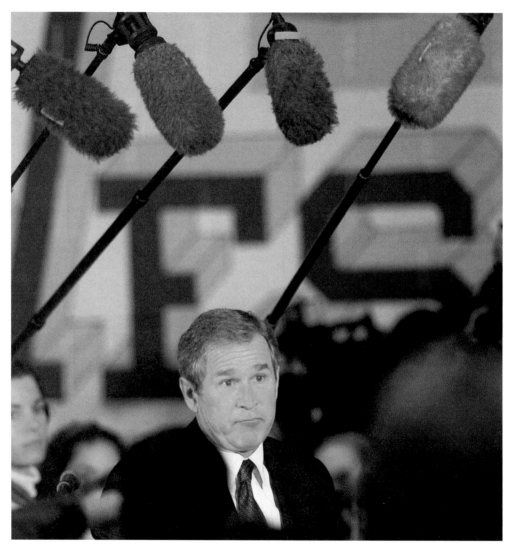

"Doberman Pinscher is the Chancellor of Germany.
Is that your final answer?"

"Now concentrate. True or false, Crepe Suzette is
the President of France?"

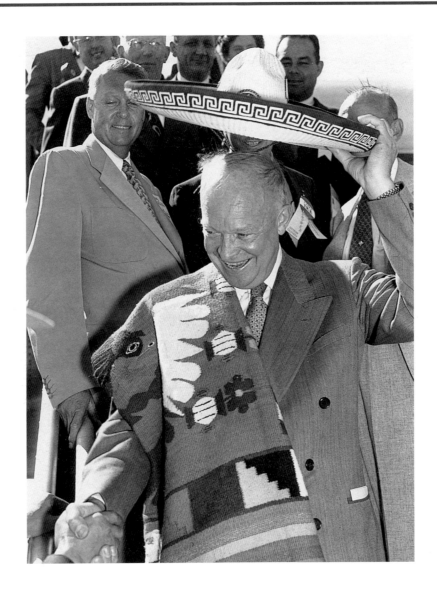

Me gusta Ike.

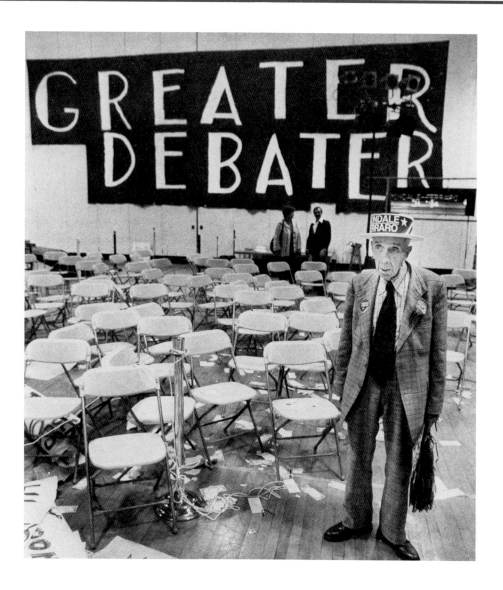

The party's over.

PHOTO CREDITS AND CAPTIONS

PHOTO CREDITS

All photos from AP/Wide World except the following:

Page 5 Don Black, *Binghamton* (New York) *Sun & Press-Bulletin*. (Nelson Rockefeller)

Page 16: David Sandler, *Concord* (New Hampshire) *Monitor*

Pages 17, 53, 74: White House Photo

Page 60: Bonnie Walker, *Philadelphia Inquirer*

Page 75: James Shepley, Time Inc.

Page 79: Bob Christy, *Times-Reporter* (Ohio)

Page 80: Jim Curley, *Columbia* (Missouri) *Tribune*

Page 93: Tom Graylish, *Philadelphia Inquirer*

THE REAL CAPTIONS

Page 4. Socks peers over the podium in the White House briefing room. He was put there by a grounds keeper who was walking the First Family pet.

Page 5. (top to bottom) Former President Ronald Reagan tries on a USC Trojan helmet during ceremonies in Los Angeles welcoming him home from Washington in 1989.

New York Governor Nelson Rockefeller models a stockman's hat—presented to him in 1959 by a Dallas banker—that turned out to be too large.

Page 6. (top to bottom) Republican presidential candidate George W. Bush returns a crying child to his mother during a campaign stop in Tacoma, WA.

Pres. Ronald Reagan shakes the trunk of an 18-month-old Asiatic elephant on the South Lawn of the White House in 1984.

Page 7. (top to bottom) Ronald Reagan has trouble holding his dog, Victory, on a flight during his first presidential campaign in 1980.

Democratic presidential hopeful Bill Bradley snags a "flying fish" at Seattle's landmark Pike Place Fish Co. during a campaign stop.

Page 8. (top to bottom) President Calvin Coolidge wears Sioux tribal headdress during ceremonies in South Dakota in 1927.

New York Mayor Rudolph Giuliani, wearing a costume from *Grease*, sits astride a motorcycle at a press dinner in 1996.

President Franklin Delano Roosevelt wears an Indian headdress as he participates in Boy Scout camp in New York in 1933.

Page 9. (top to bottom) President Ronald Reagan gives photographers the ear wiggle at a photographer's dinner in Washington in 1986.

Vice President Nelson Rockefeller gives the finger to hecklers in Binghamton, NY, during a political appearance in 1976.

Page 11. Hillary Clinton struggles with a microphone cord before a television interview in Washington in 1995

Page 12. Gov. George Bush of Texas flips flapjacks during a pancake flipping contest in Manchester, NH, in 2000.

Page 13. Pres. Nixon views Apollo 11 astronauts in isolation chamber aboard USS Hornet after splashdown and recovery July 24, 1969. Astronauts are (l to r) Neil Armstrong, Michael Collins and Buzz Aldrin.

Page 14. Entertainer Sammy Davis Jr. hugs President Richard Nixon during an appearance in Miami Beach in 1972.

Page 15. President Bill Clinton applauds during an adoption event in Washington, DC, in 1999. Seated with him is Brian Keane, 11, an adoptee.

Page 16. Bill Bradley, seeking the Democratic presidential nomination, visits a day-care center in Henniker, NH., in 1999.

Page 17. President Ronald Reagan cuts in on Frank Sinatra as the singer dances with First Lady Nancy Reagan at a White House party in 1981.

Page 18. President Lyndon Johnson picks up his pet Beagle, Her, by the ears outside the White House in 1964.

Page 19. President Bill Clinton flips a frisbee as swimmers do hand stands in the ocean at Hawaii in 1993.

Page 20. Sen. John McCain inspects the podium as a staff member has a laugh at the senator's expense in San Diego in 1996.

Page 21. Vice President Nixon wipes a windshield as part of a March of Dimes fund-raising effort in Washington in 1955.

Page 22. President Clinton shows how close he was to a successful putt during a golf match in Massachusetts in 1997.

Page 23. Elizabeth Dole holds a gun lock and aspirin in her hands as she addresses the Yale School of Medicine in Connecticut in 1999.

Page 24. Presidential candidate George W. Bush greets voters at a parking lot in Bedford, NH in 2000.

Page 25. Presidential hopeful Pat Buchanan addresses students at Lutheran North High School in Michigan in 1999.

Page 26. Former President George Bush makes rabbit hears behind Barbara Bush during dedication ceremonies of The Ford Library and Museum in Michigan in 1997.

Page 64. Presidential hopeful Pat Buchanan holds two piglets during a campaign stop at a farm in Iowa in 1999.

Page 65. President George Bush holds a baby as he greets supporters at a Georgia campaign stop in 1992.

Page 66. Attorney General Janet Reno responds to questions at a National Press Club luncheon in Washington, DC, in 1993.

Page 67. New York Gov. Mario Cuomo ponders a question during a press conference in Massachusetts in 1988.

Page 68. Presidential hopeful Pat Buchanan attempts to make a child laugh during a campaign fundraiser in California in 1999.

Page 69. House Speaker Newt Gingrich "wears" a Binturong bearcat as a hat in his Washington, DC, office. Several animals were in the office with zoo officials from Columbus, Ohio.

Page 70. Mayor Rudolph Giuliani is dressed in drag for an appearance before the New York Press Club in 1997.

Page 71. Richard Nixon shows his badminton service to Chinese watchers in Hong Kong during a visit in 1964.

Page 72. President Richard Nixon flies a toy airplane presented to him by the graduating class of the US Naval Academy in 1974.

Page 73. President Richard Nixon struggles with a yo-yo given to him at a performance at the Grand Ol' Opry in 1974 in Tennessee.

Page 74. President Nixon shakes hands with Elvis Presley in the White House in 1970.

Page 75. Vice President Richard Nixon climbs back into a boat after falling into the water during a fishing trip in the Florida everglades in 1955.

Page 76. Socks and Buddy, White House cat and dog, have a troubled first meeting outside the Oval Office in 1998. President Bill Clinton mediates.

Page 77. Presidential candidate George W. Bush puts body English into his follow through during candlepin bowling in New Hampshire in 2000.

Page 78. President elect George Bush delivers an acceptance speech in Houston in 1988. Wife Barbara covers up the mouth of their yawning granddaughter (also named Barbara).

Page 79. Presidential hopeful Sen. John McCain greets supporters at a rally in Ohio in 2000.

Page 80. Vice President George Bush campaigns at the University of Missouri in 1984, where he drew some 400 students and three bovine listeners.

Page 81. Hillary Clinton visits senior citizens at a Salvation Army during a campaign stop in New York in 2000.

Page 82. Asked about his recovery from a gall bladder operation, President Lyndon Johnson pulls up his shirt and shows his scar at his ranch in 1965.

Page 83. New York Gov. George Pataki sits under a portrait of President Theodore Roosevelt during a 1998 interview in Pataki's office.

Page 84. Jesse Jackson prepares a cow for milking in Iowa in 1987 prior to the Iowa caucuses.

Page 85. House Speaker Newt Gingrich gathers his thoughts before speaking to a synagogue congregation in Georgia in 1995.

Page 86. Vice President George Bush talks to schoolchildren in New York City during his campaign in 1988.

Page 87. Presidential hopeful George W. Bush stands with bandleader Michael Brown during a campaign stop at a high school in Delaware in 2000.

Page 88. The Harlem Globetrotters toss a ball to Secretary of State Henry Kissinger during a Washington visit in 1978.

Page 89. President Bill Clinton laughs at a comment Russian President Boris Yeltsin made to journalists at a press conference in New York in 1995.

Page 90. Boom microphones hover over George Bush as he meets with a crowd during a campaign visit to Ohio in 2000.

Page 91. Presidential hopeful George W. Bush prepares to roll his bowling ball during a candlepin game in New Hampshire in 2000.

Page 92. Presidential nominee Dwight Eisenhower tries on Mexican dress prior to a political speech in California in 1952.

Page 93. It's all over at a Presidential debate held in Philadelphia in 1988.